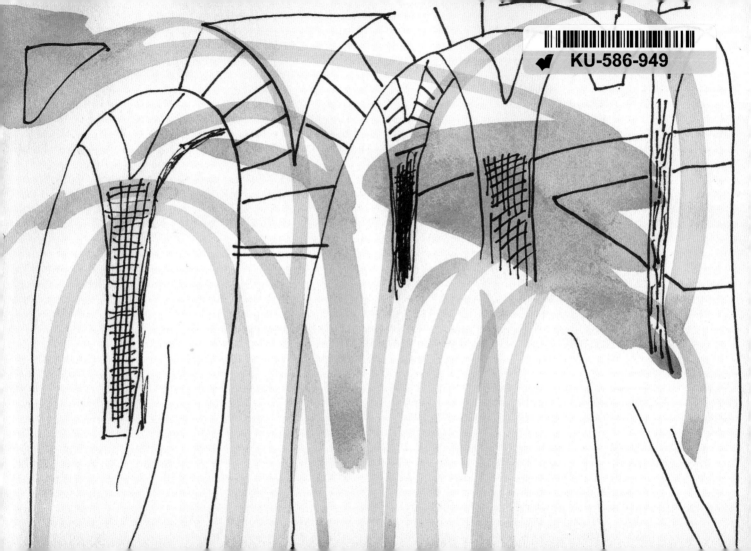

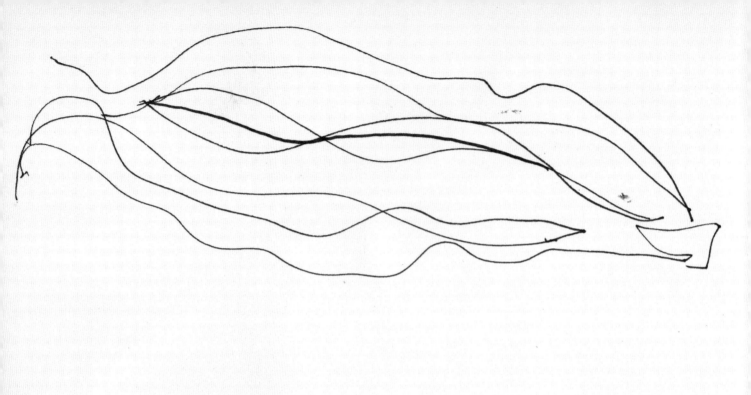

Yorkshire
April 04

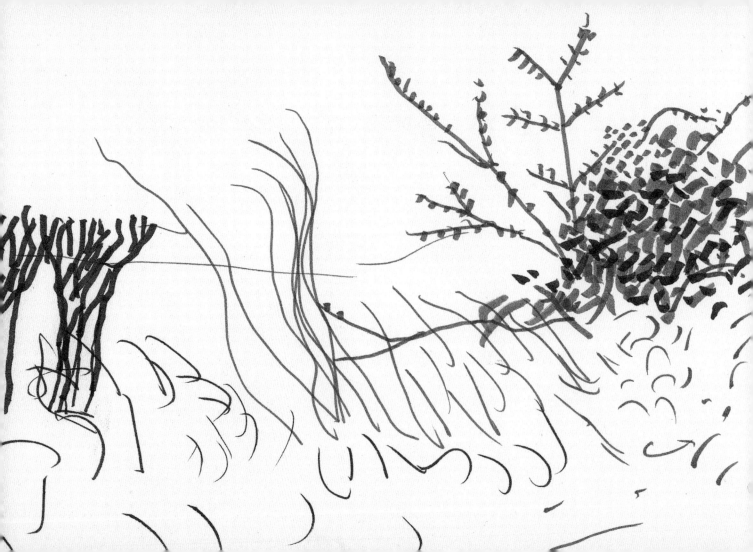

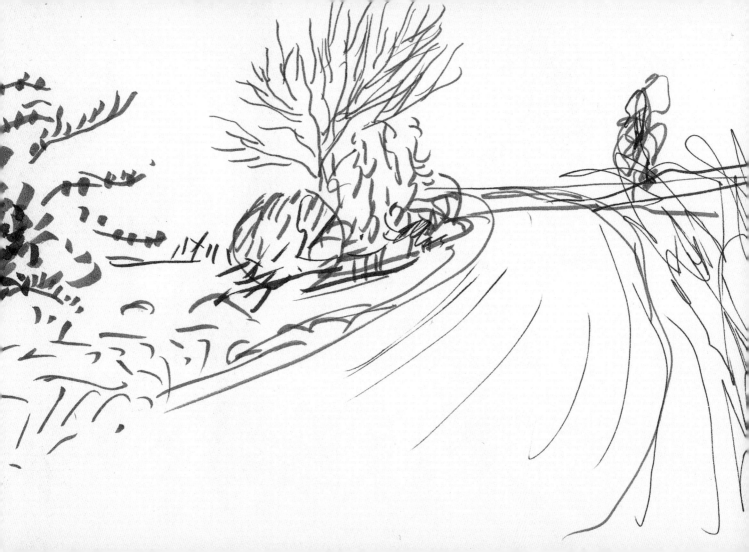

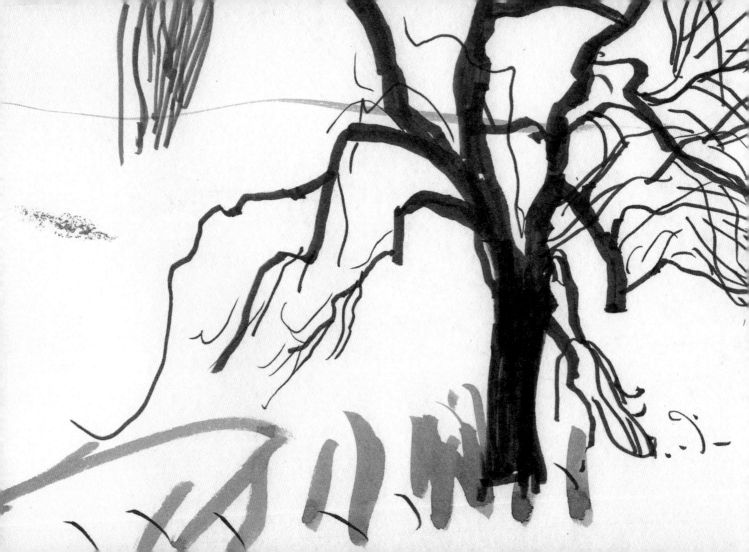

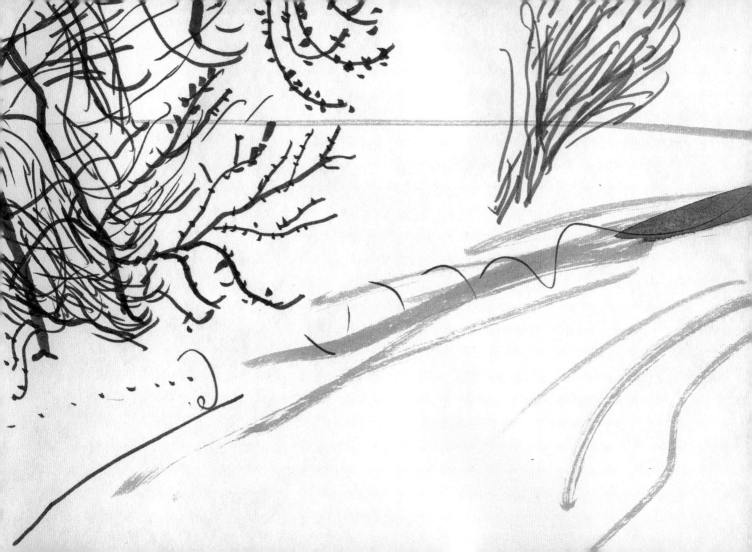

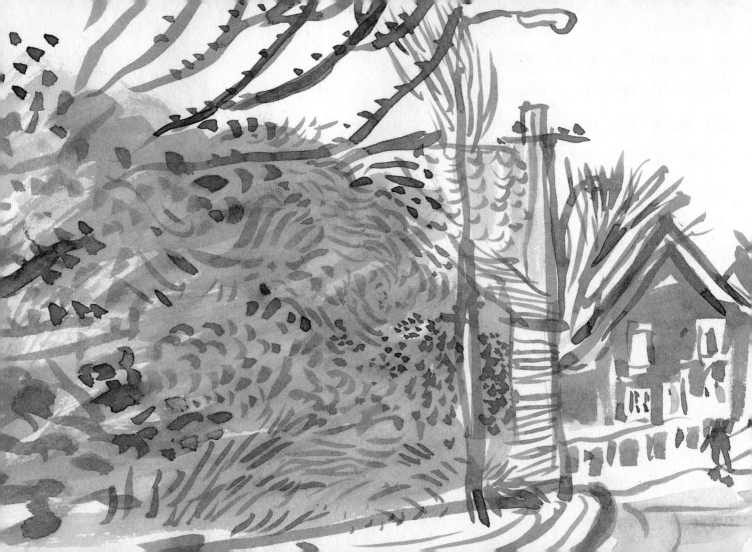

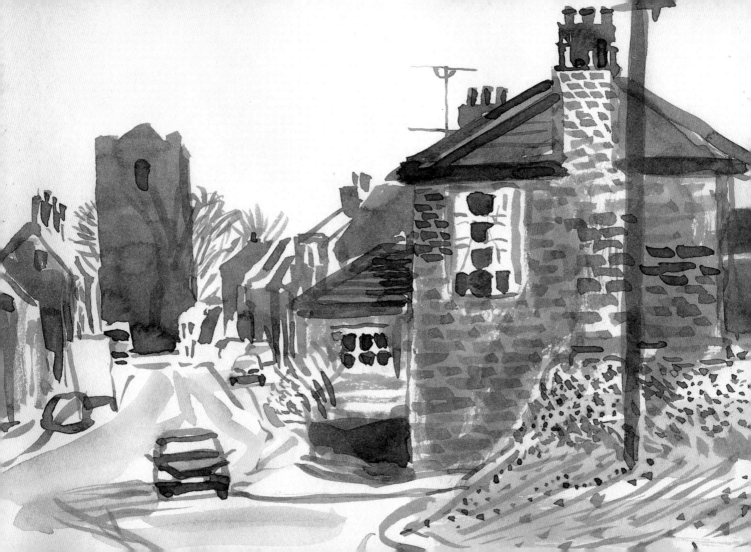

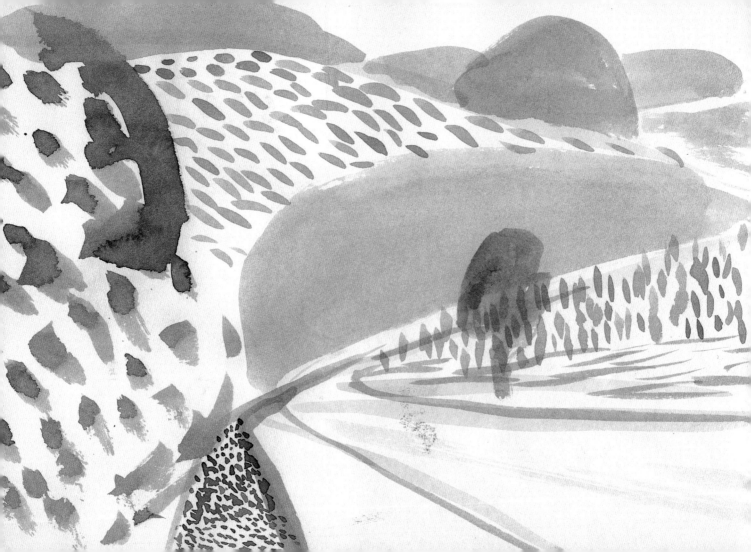

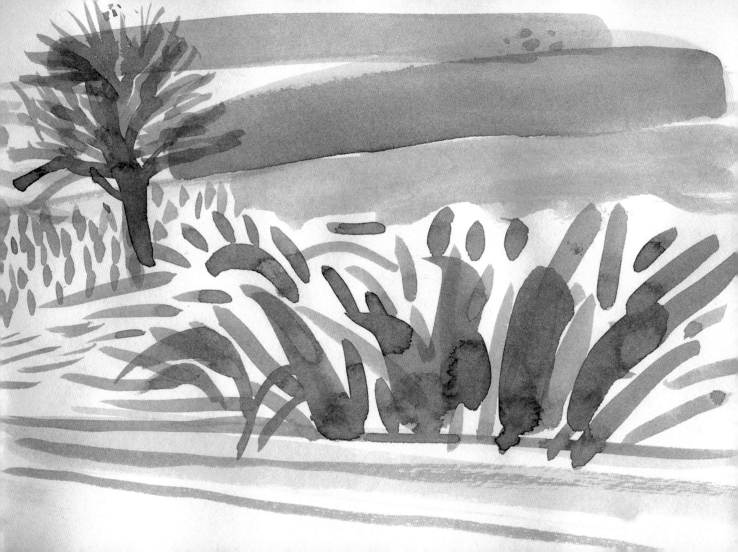

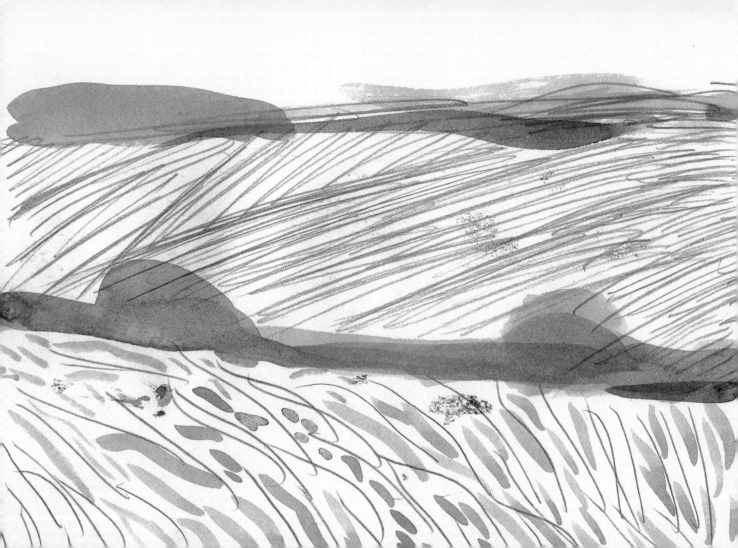

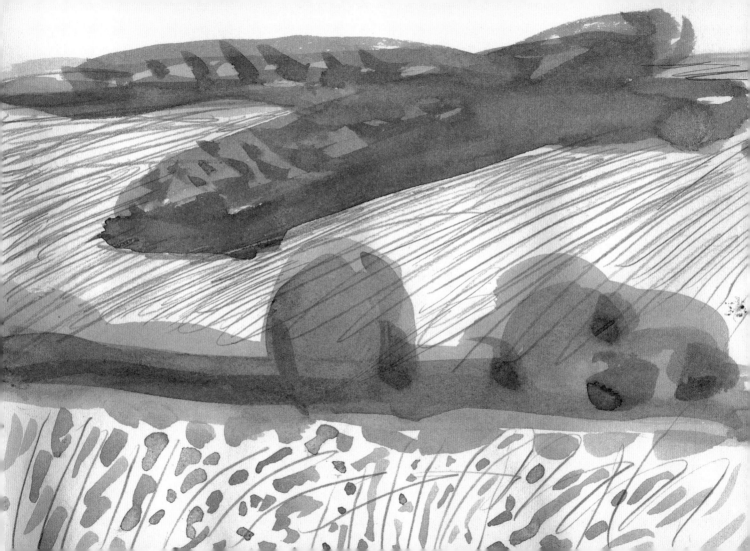

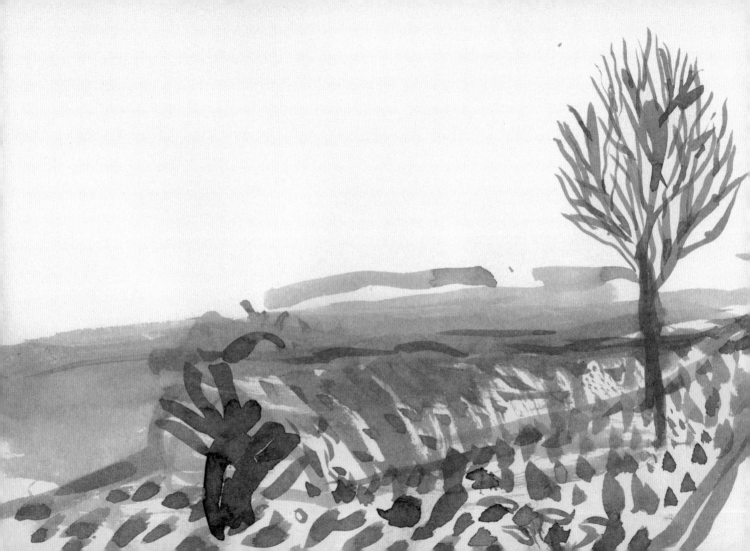

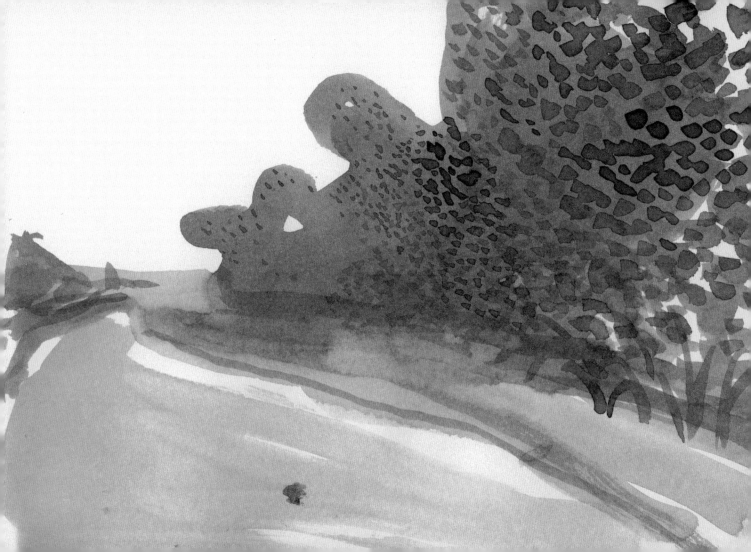

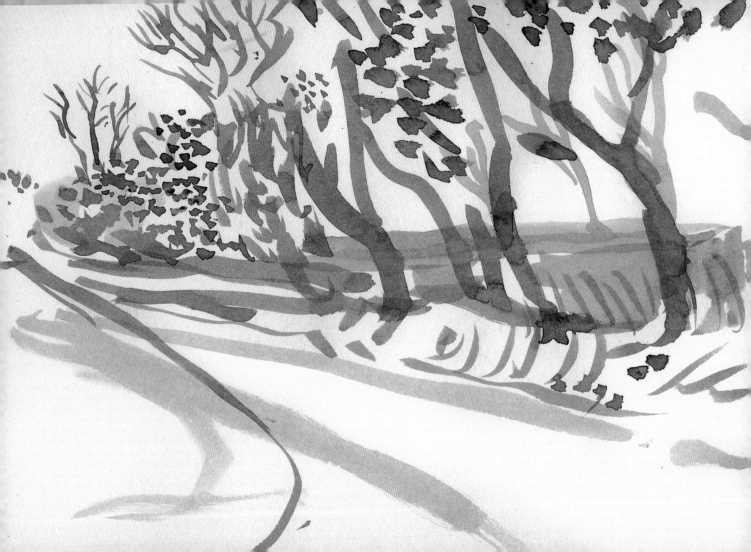

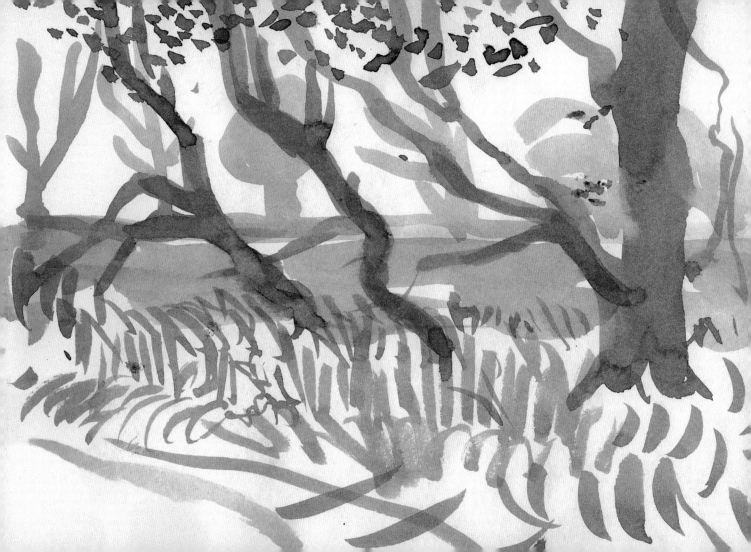

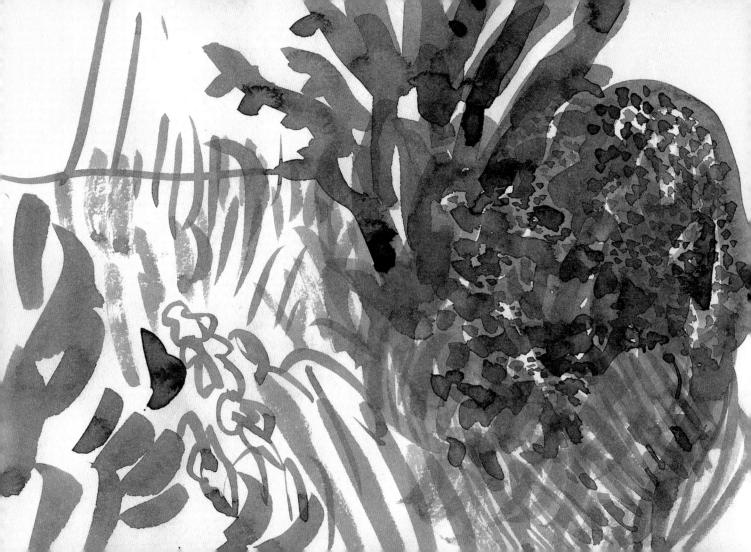

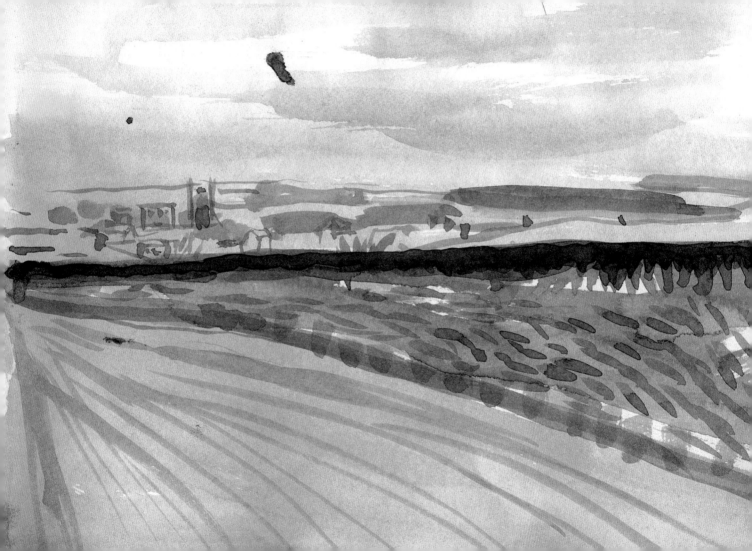

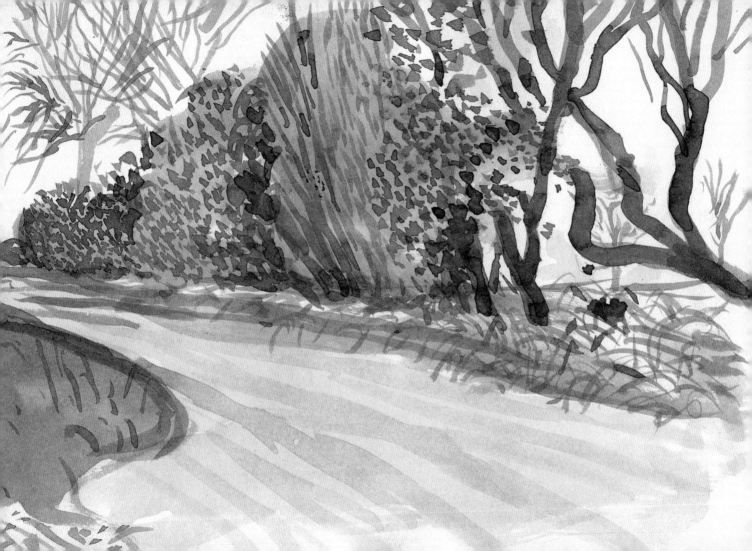

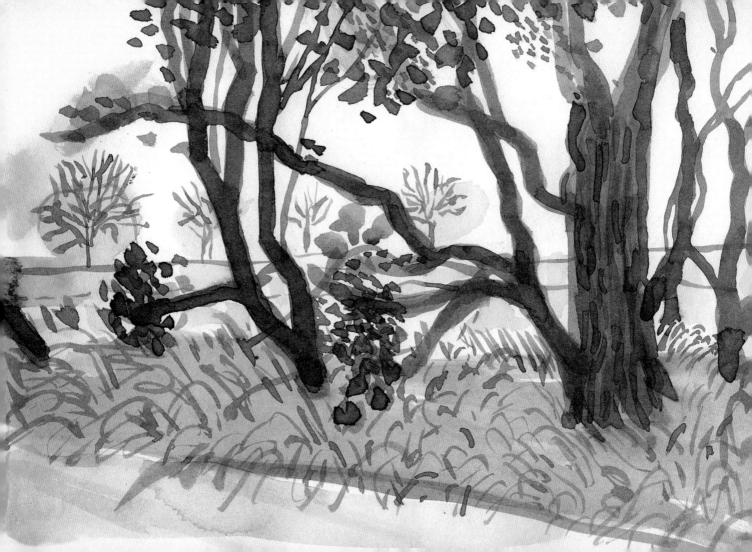

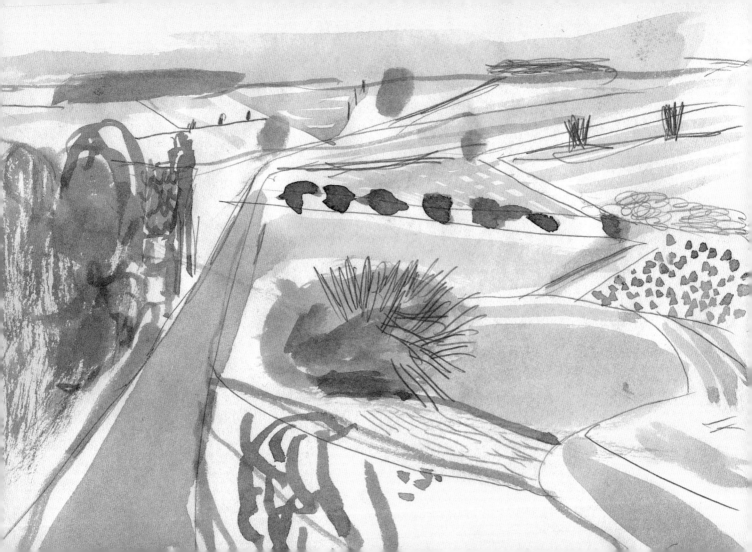

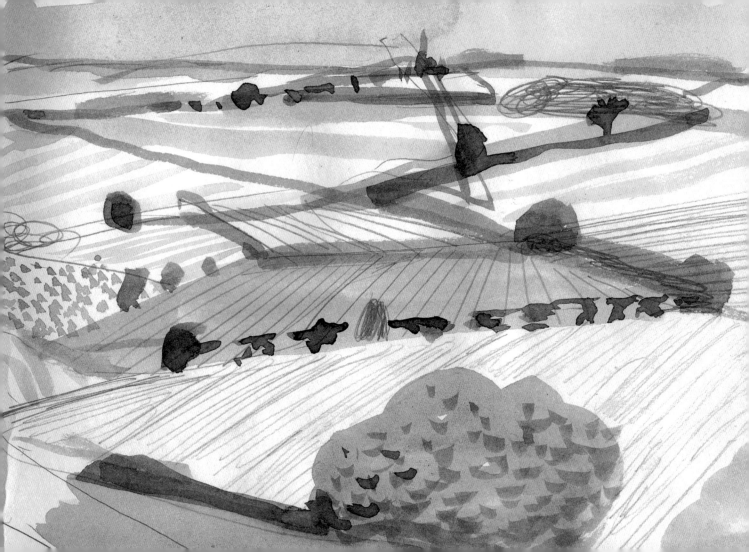

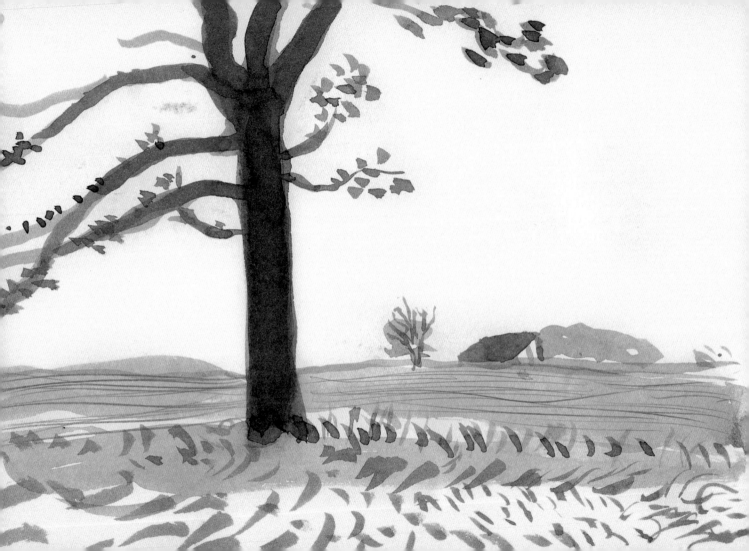

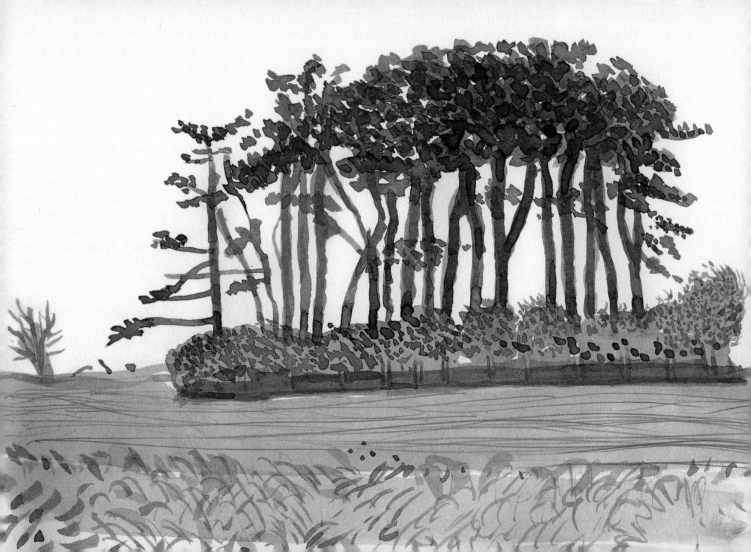

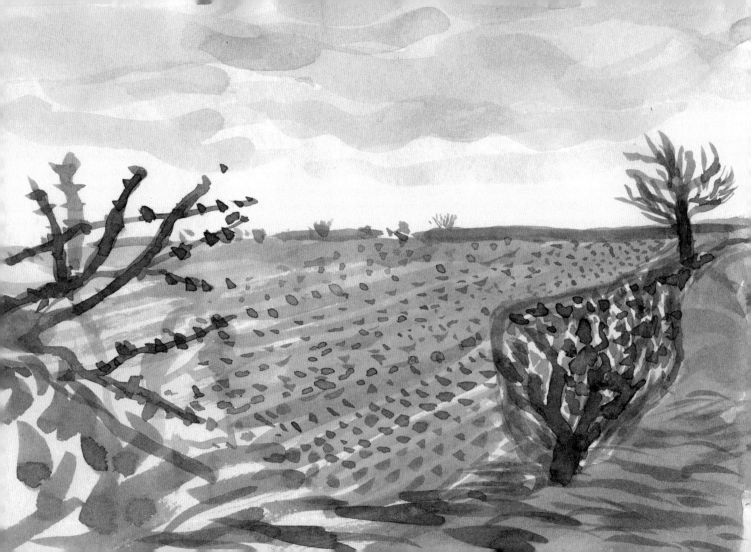

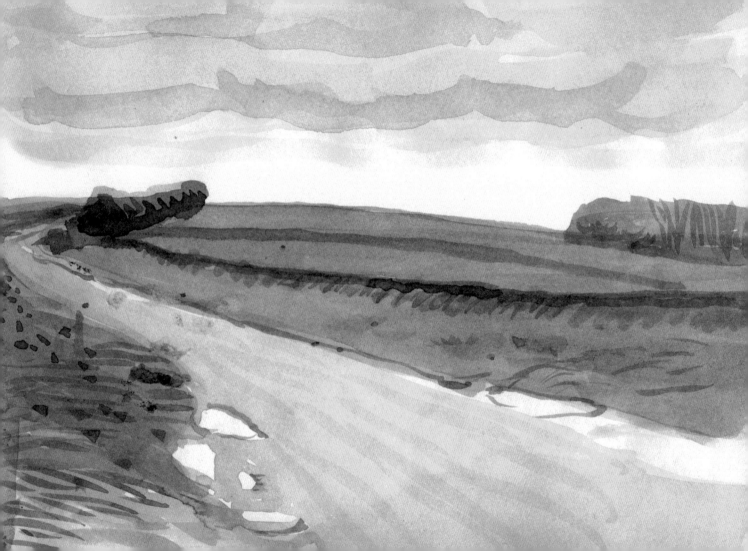

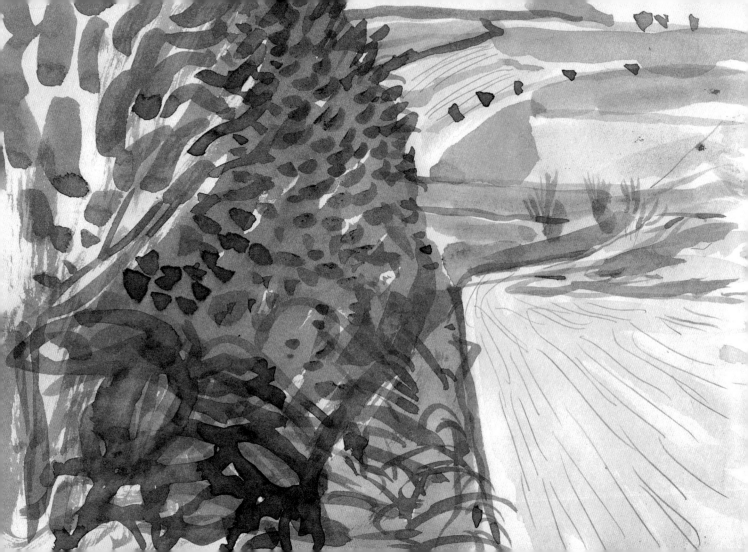

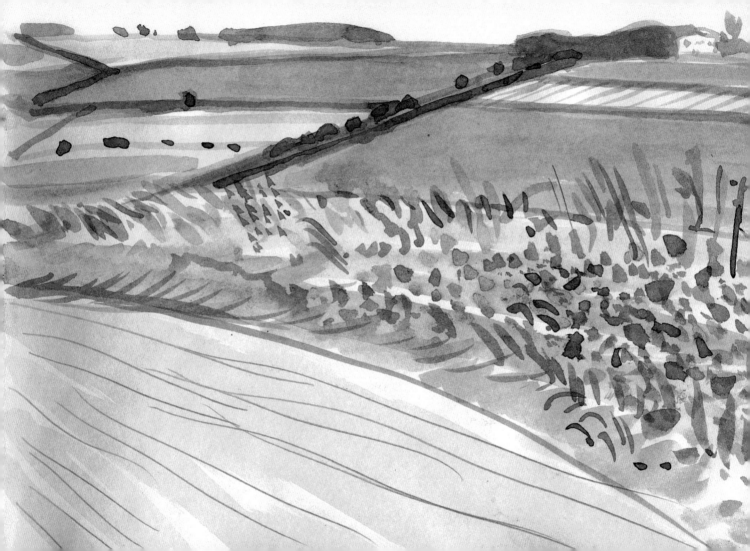

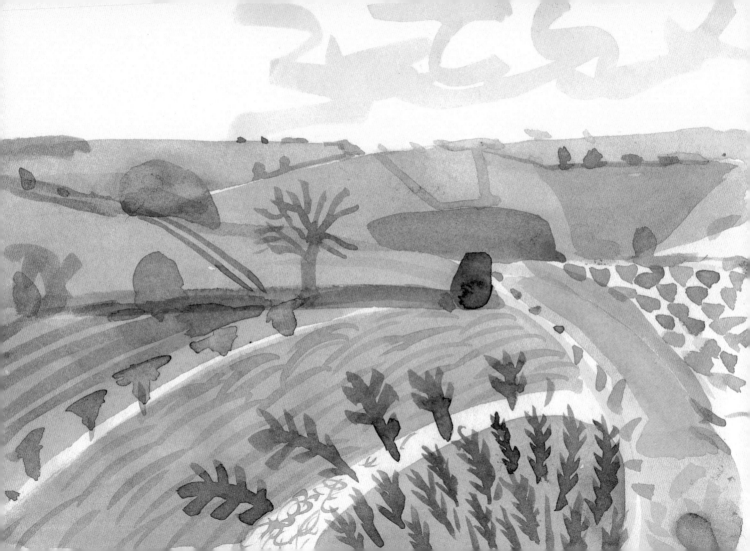

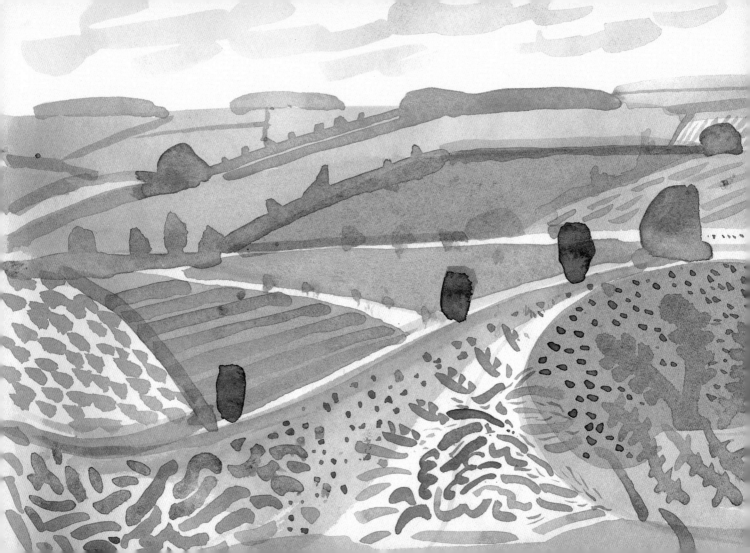

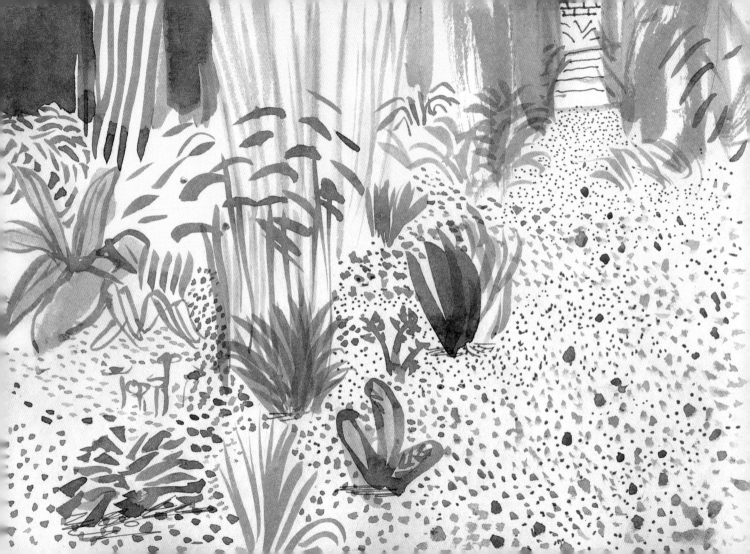

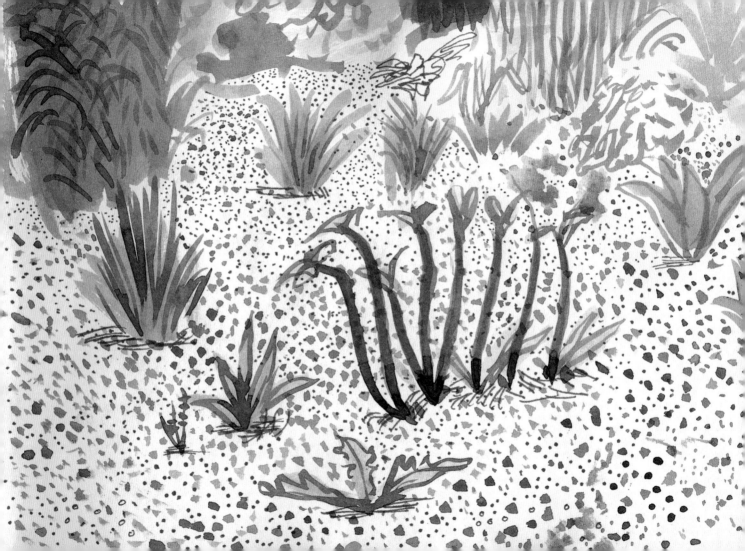

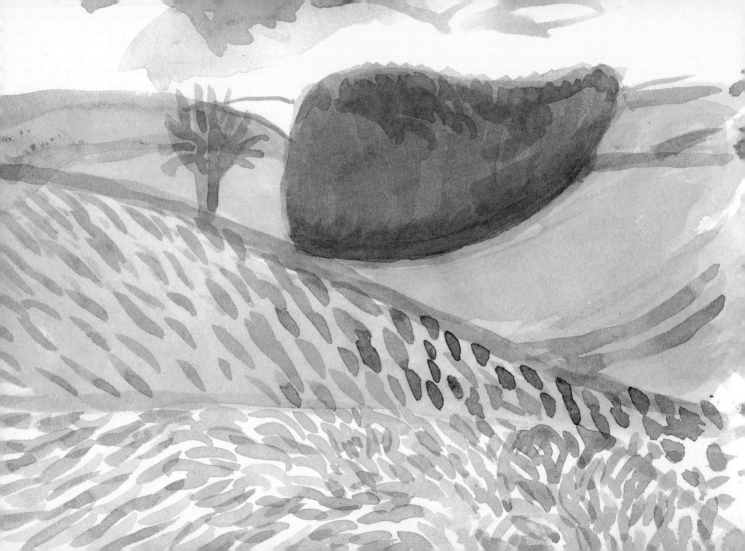

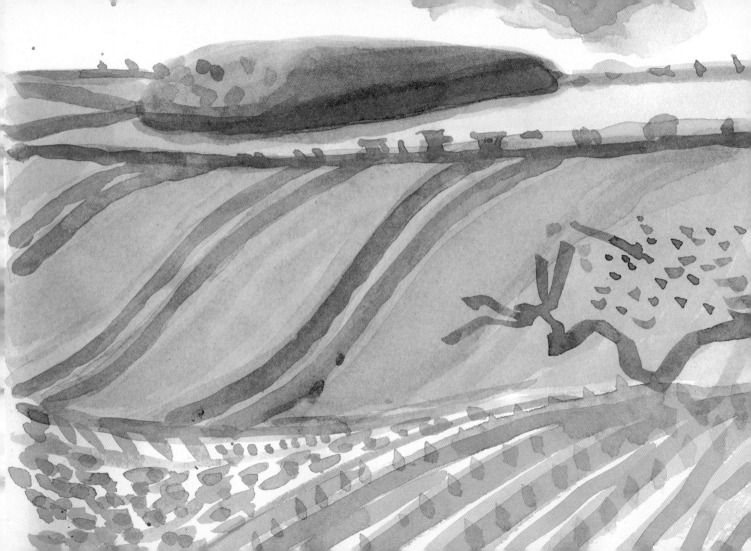

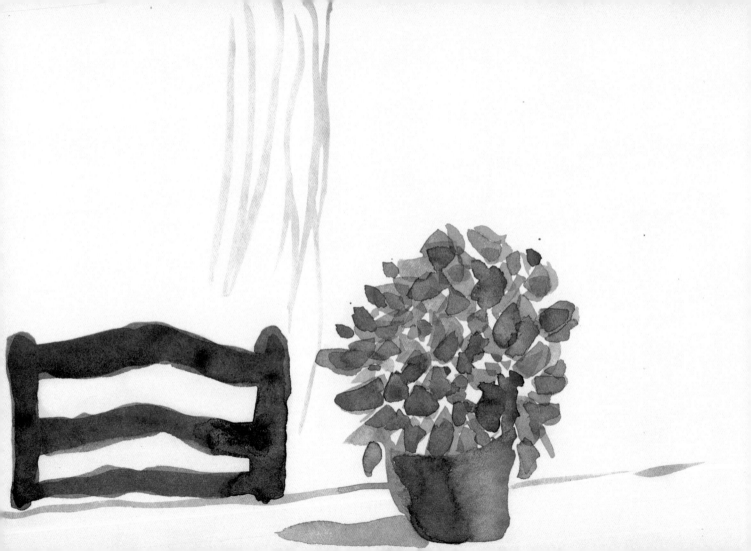

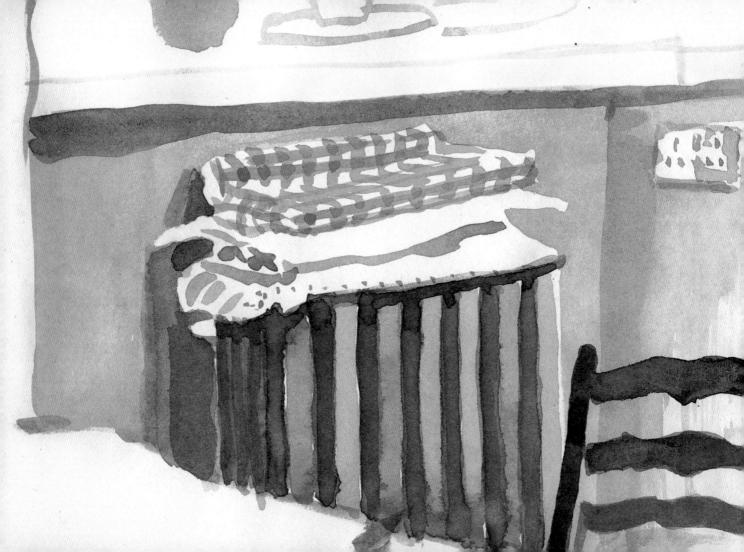

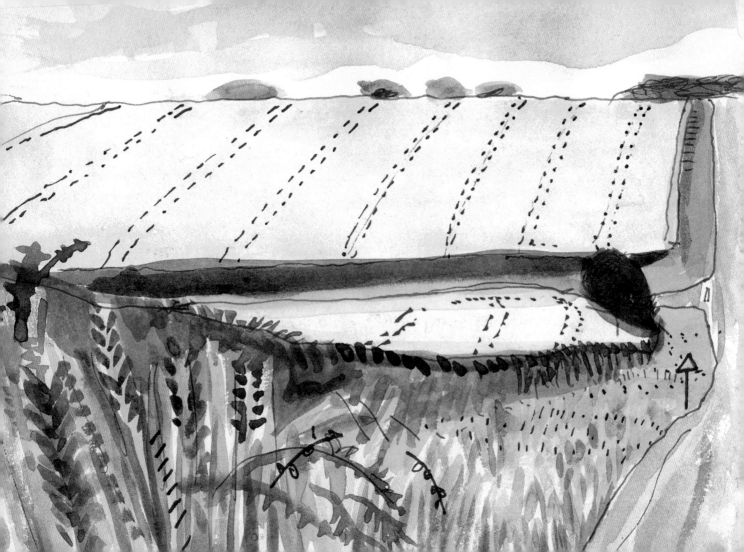

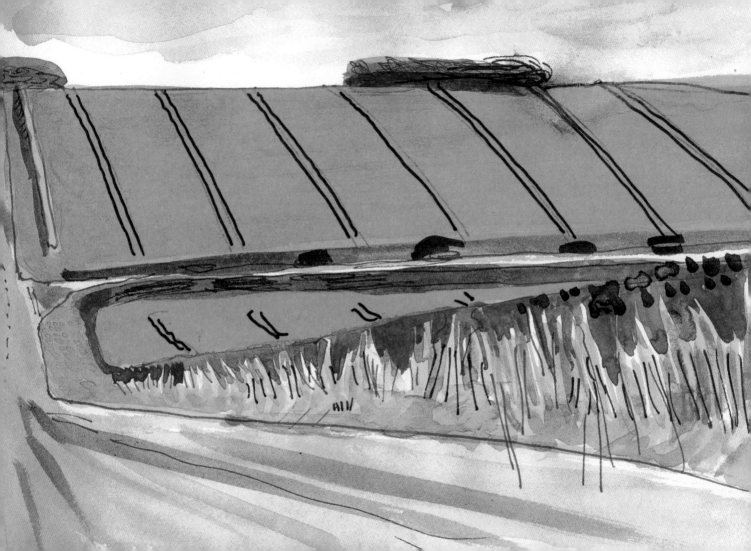

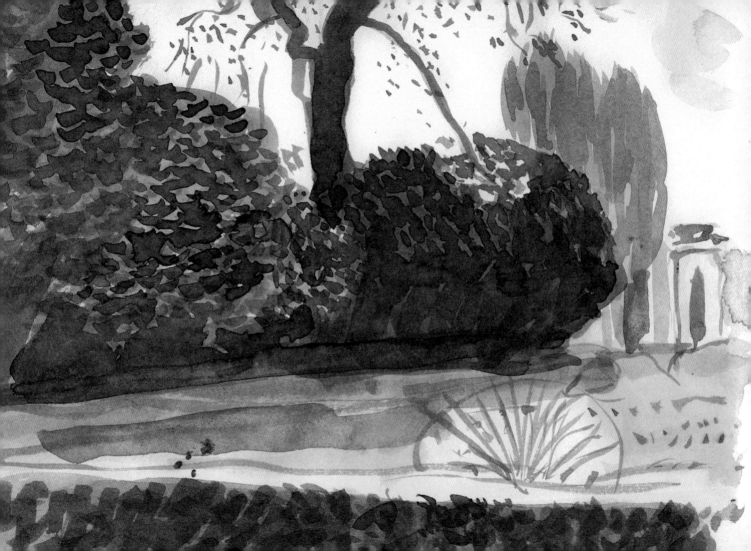

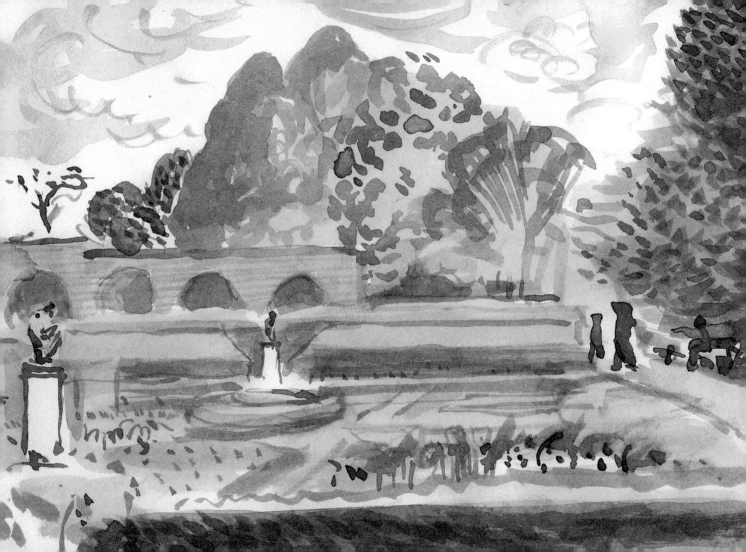

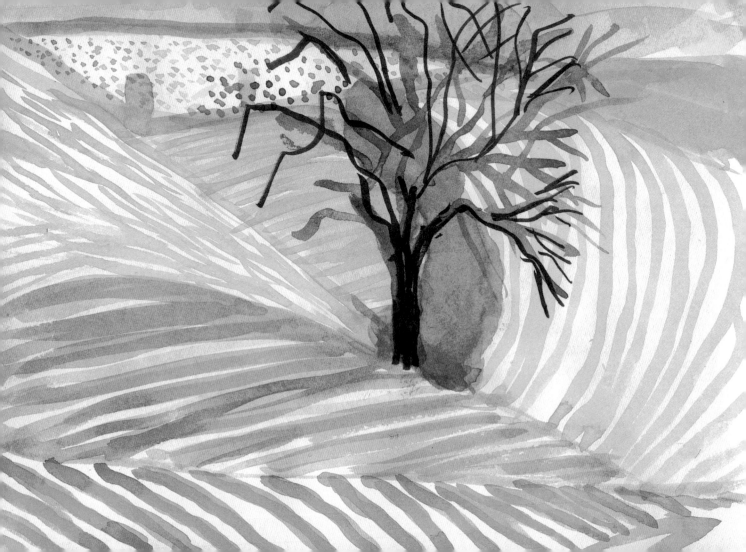

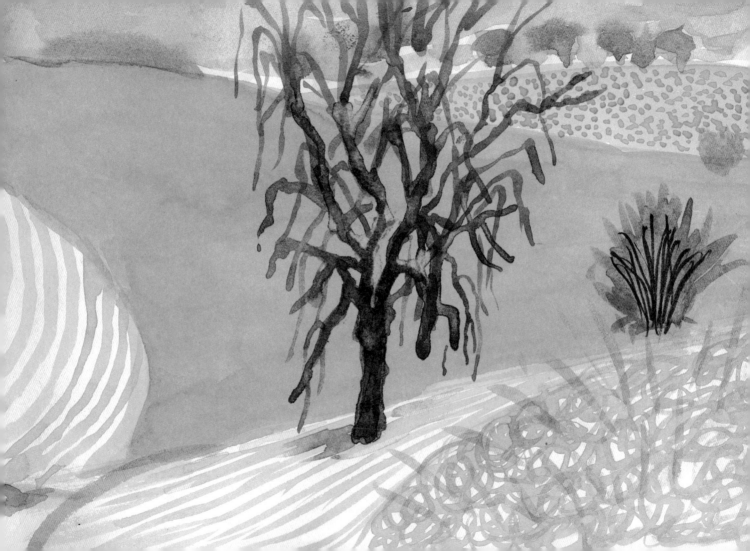

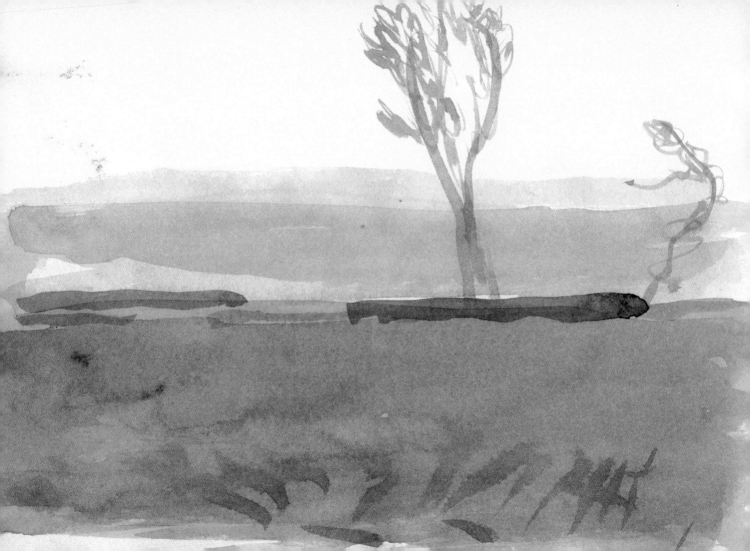

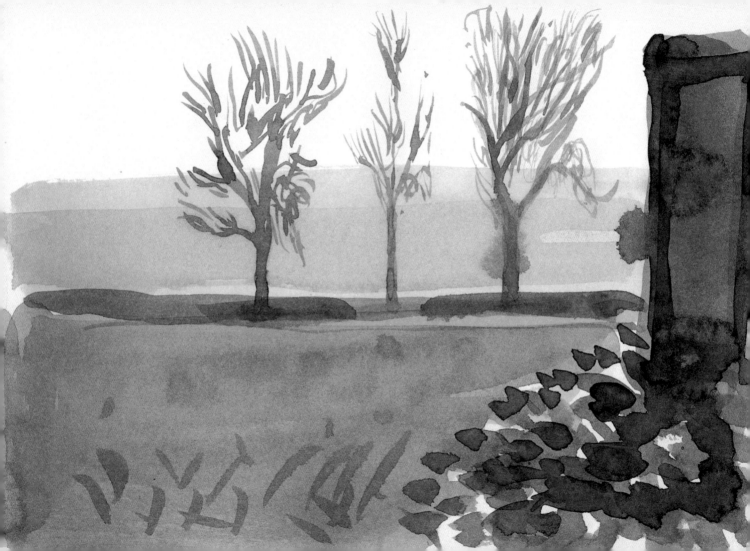

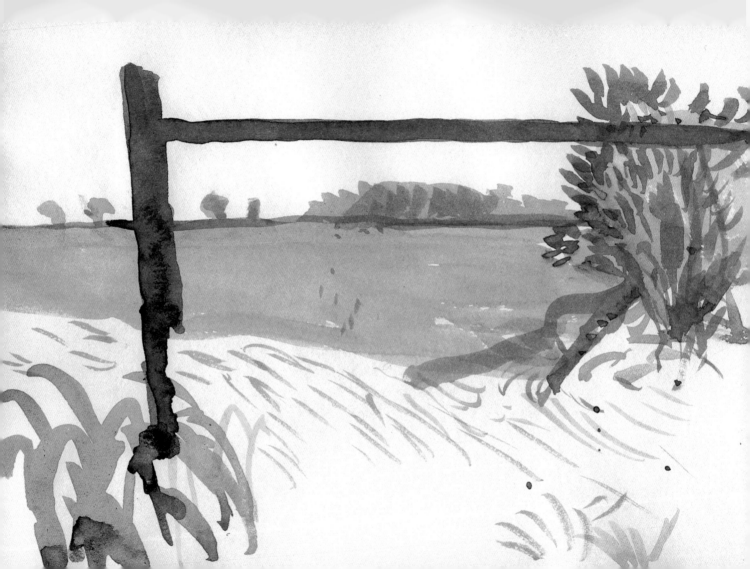

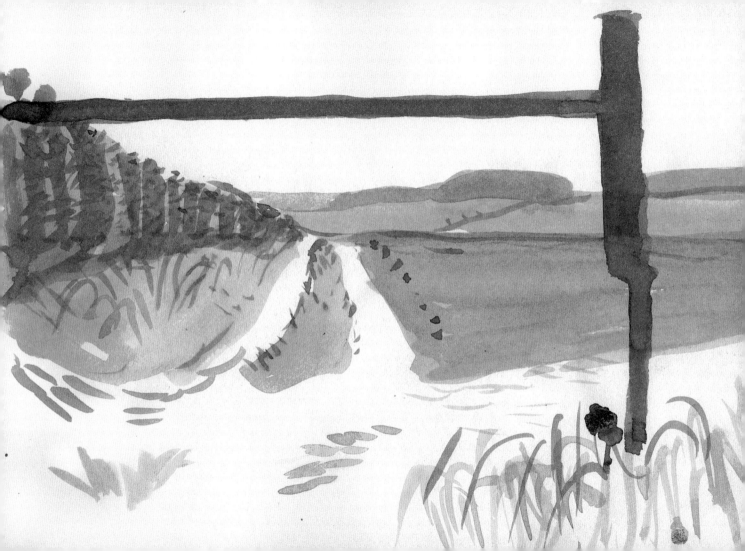

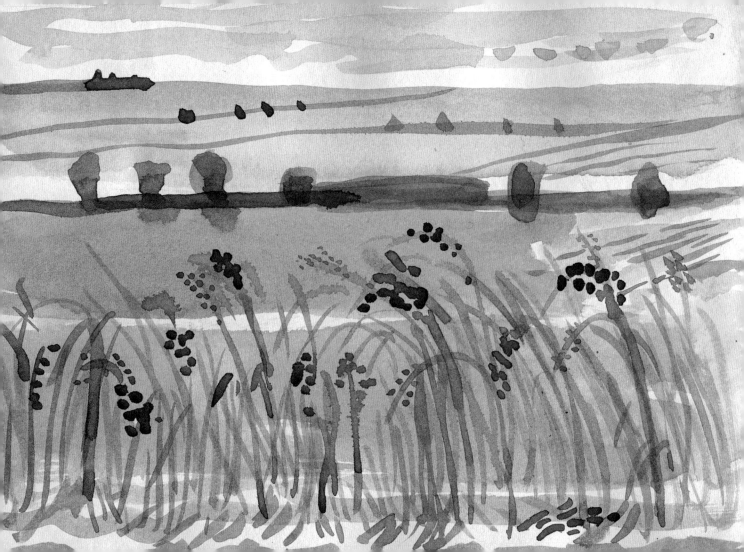

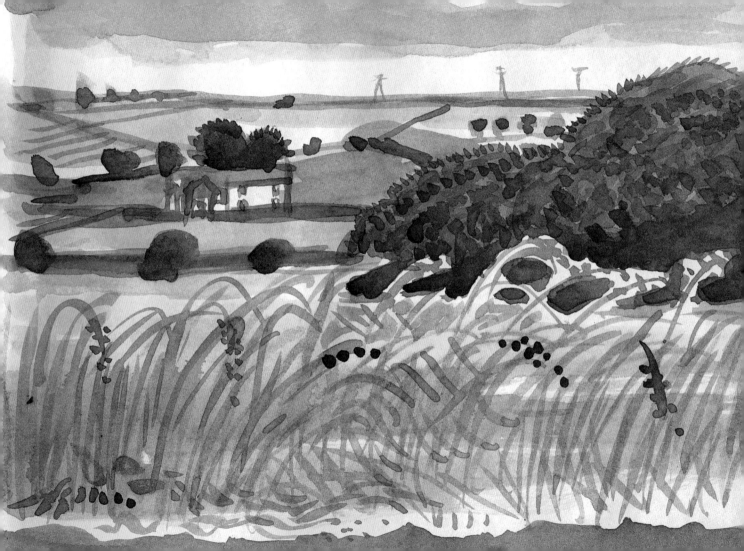

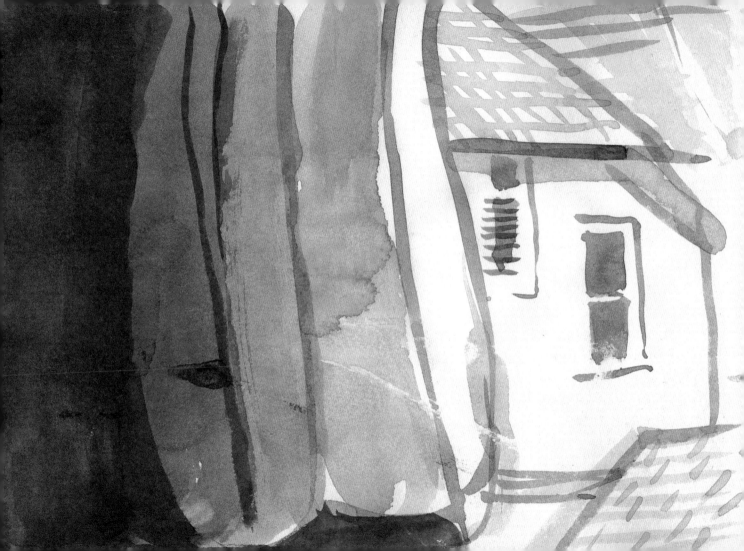

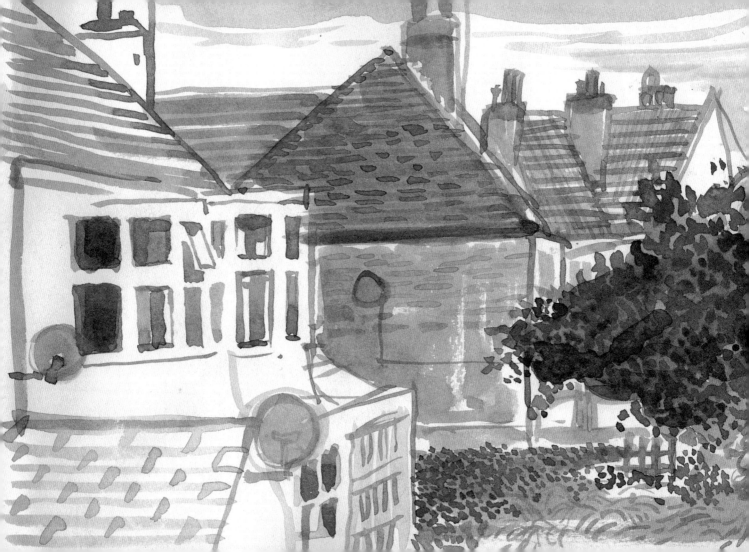

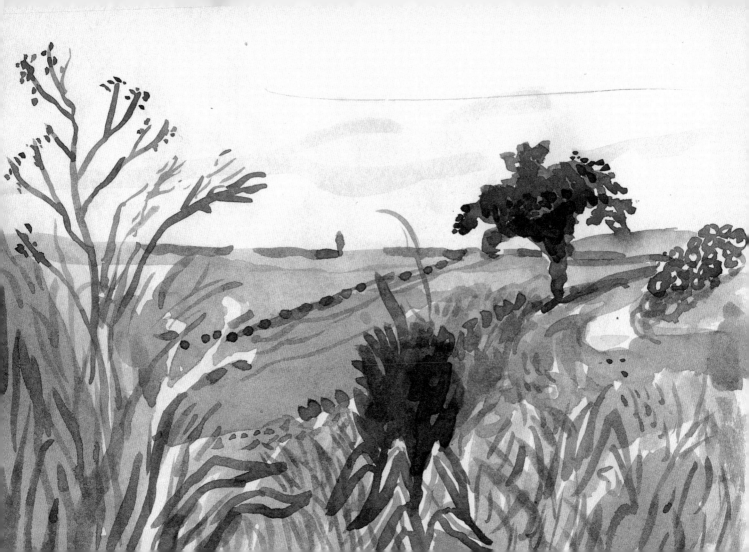

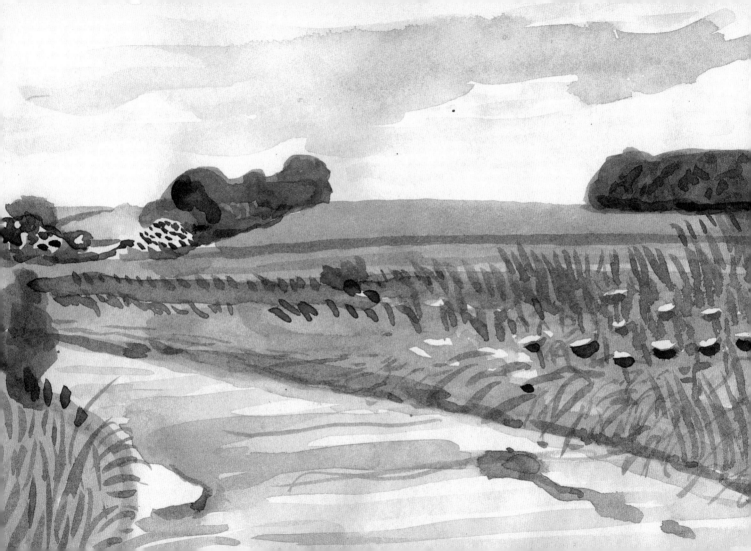

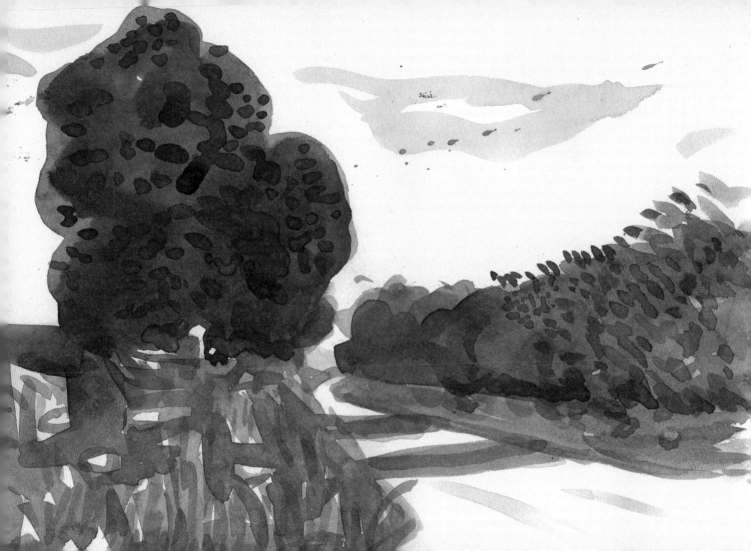

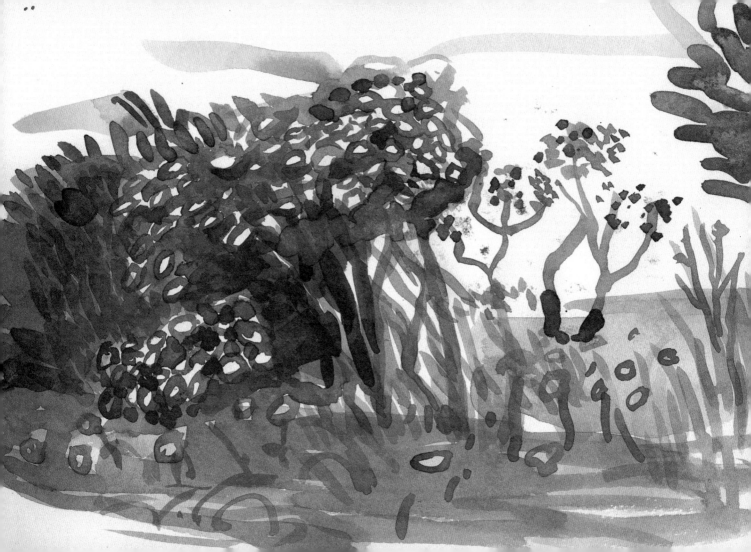

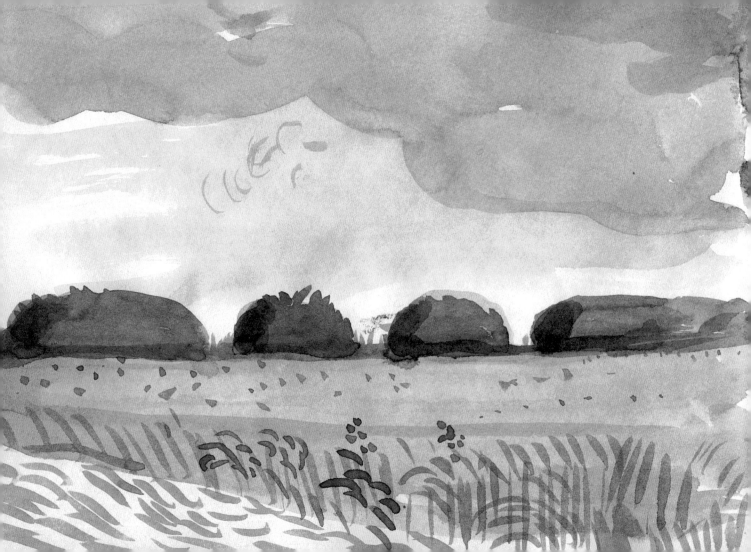

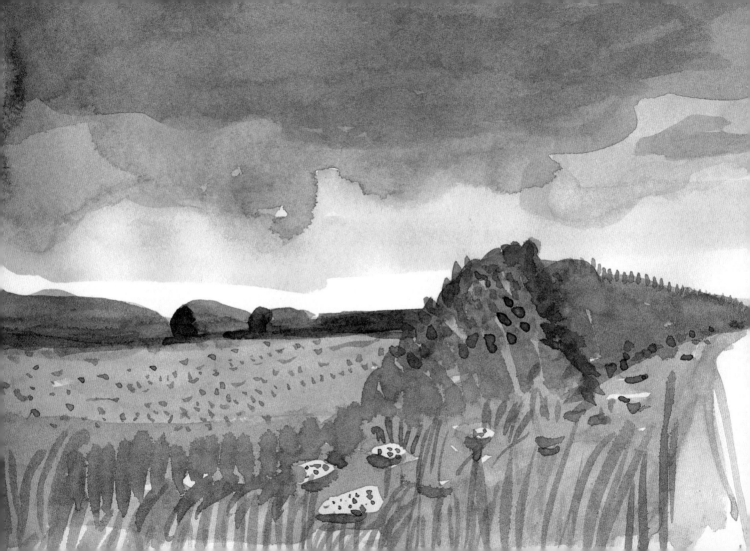

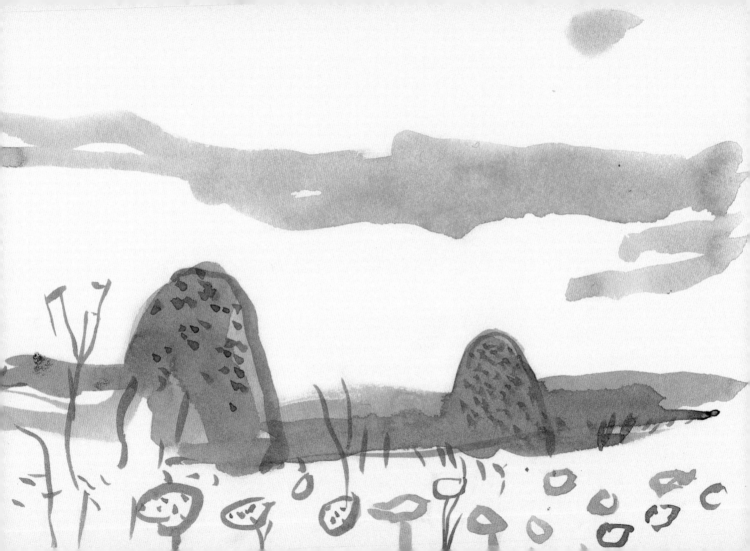

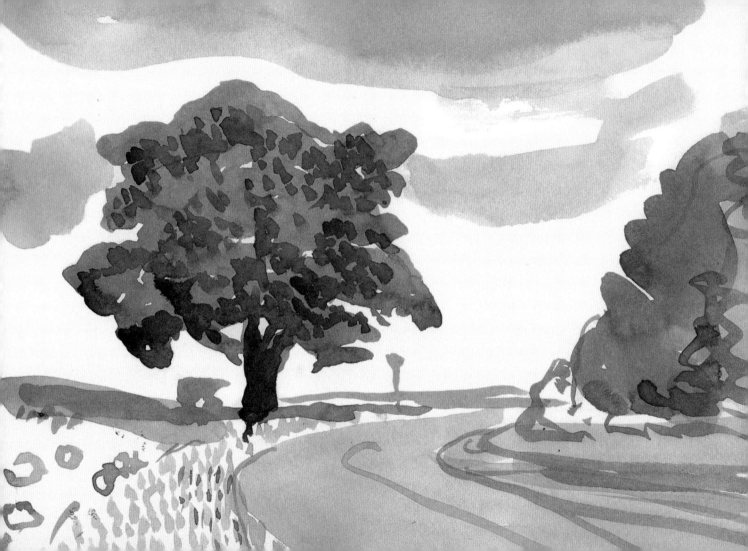

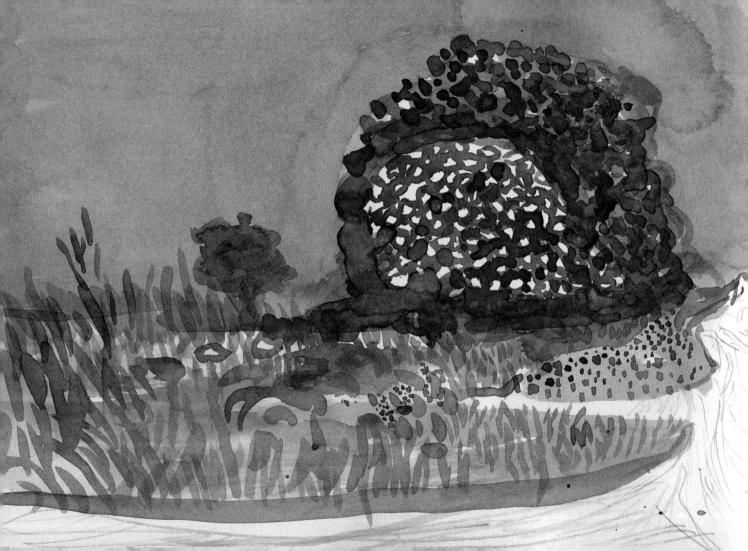

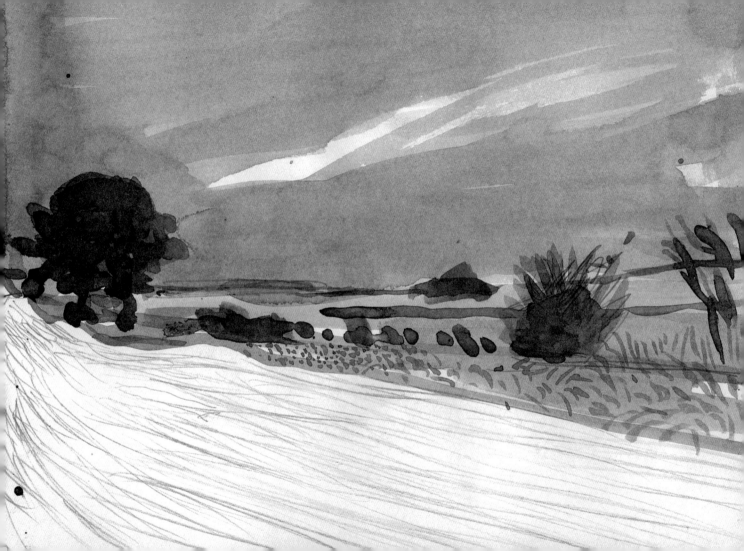

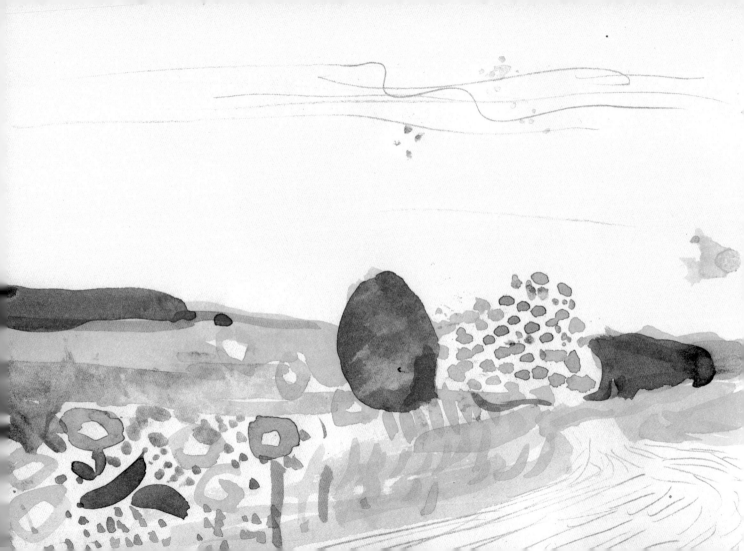

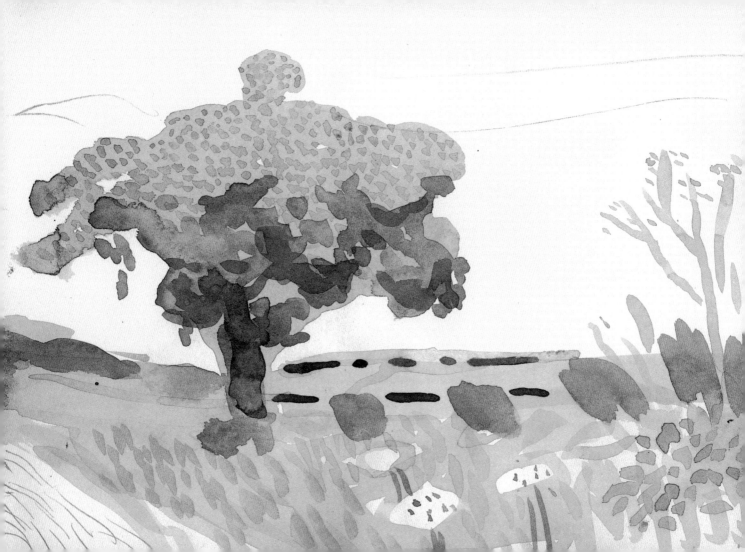

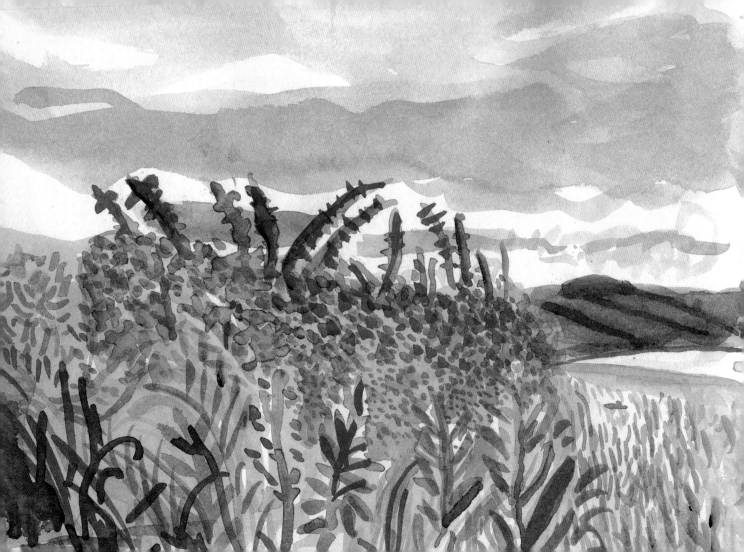

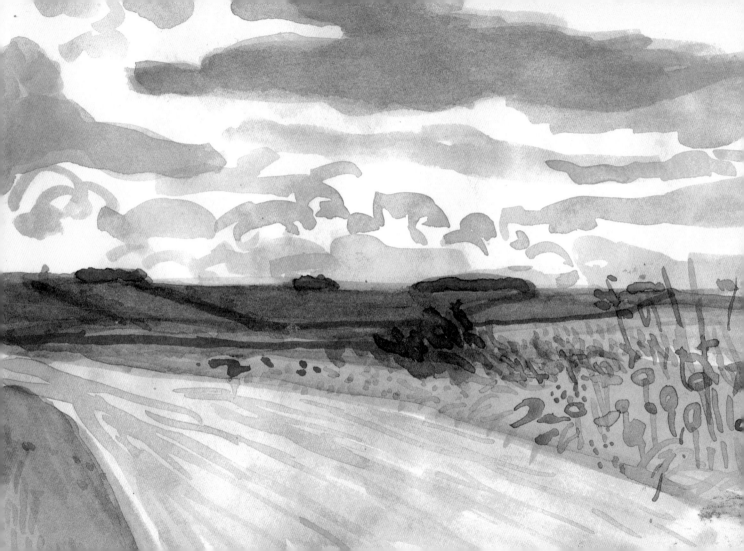

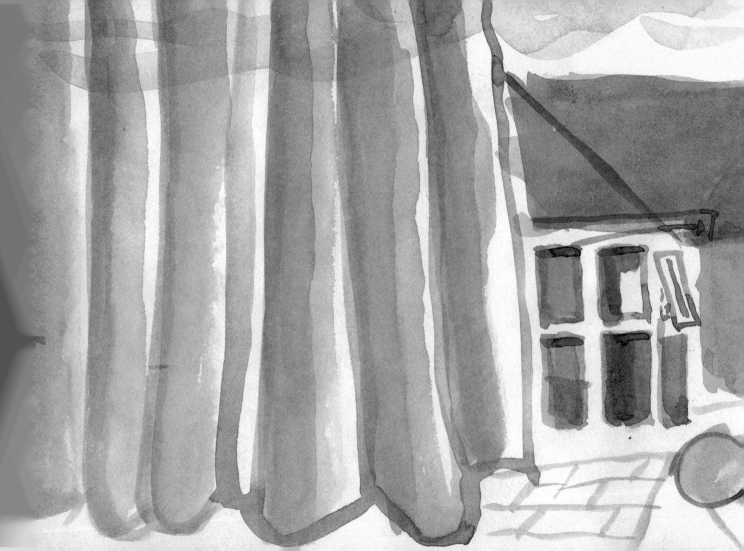

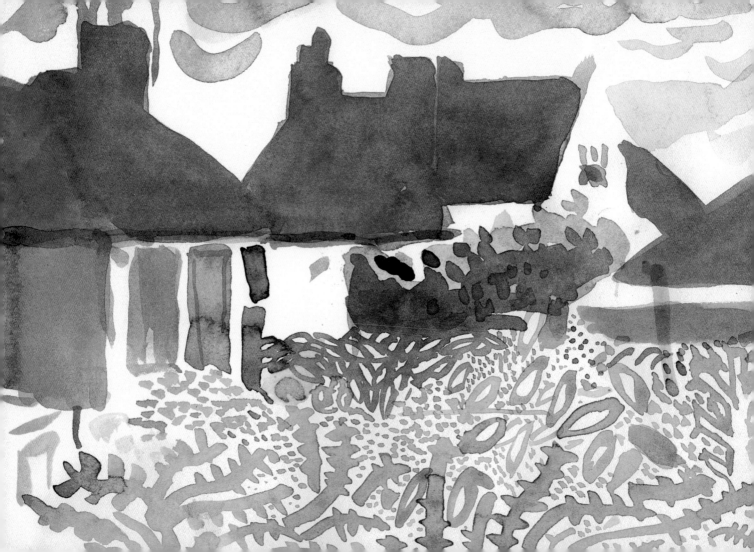

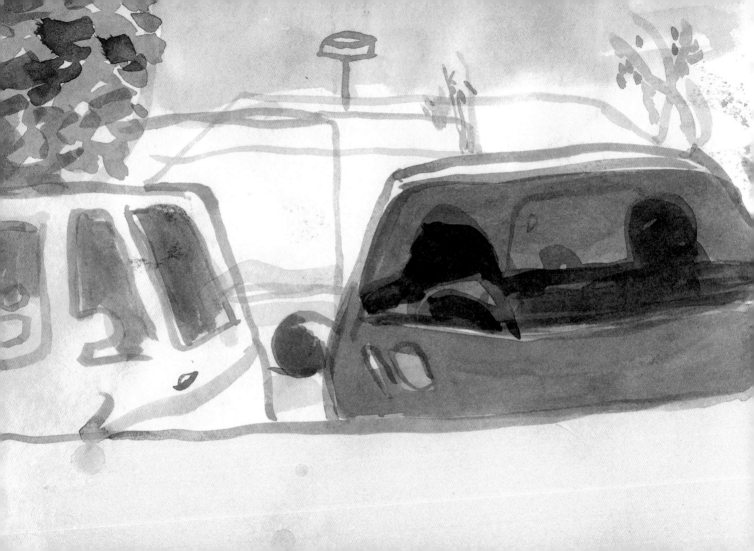

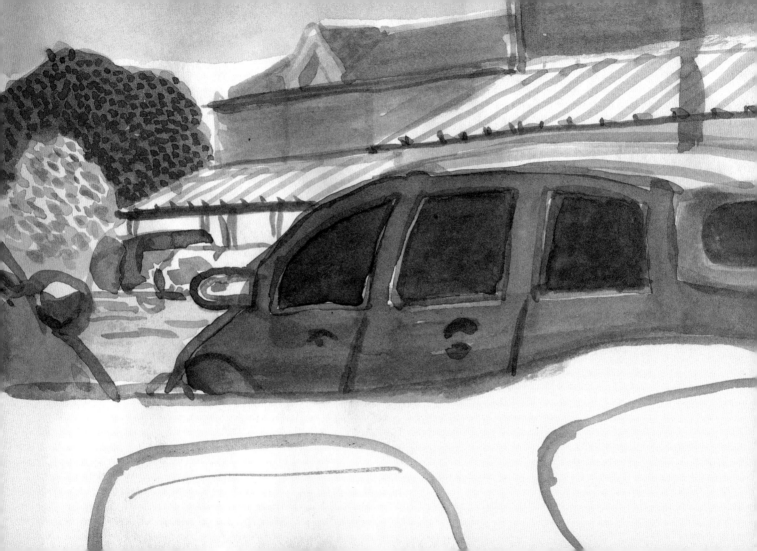

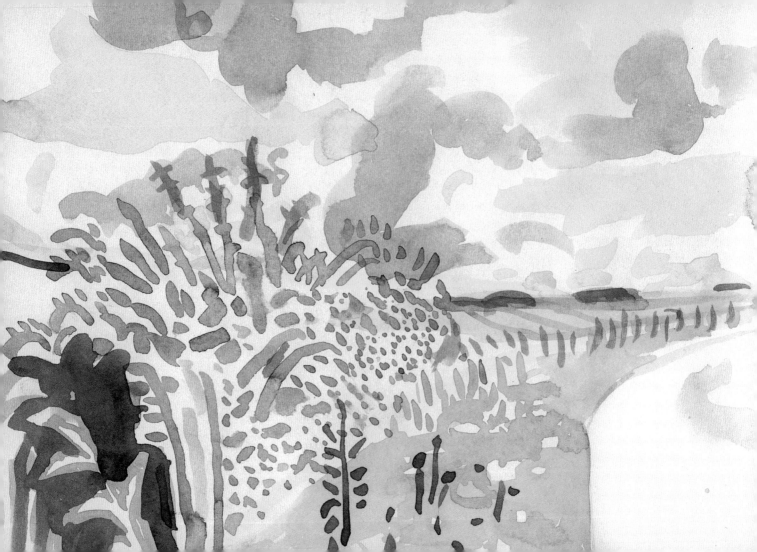

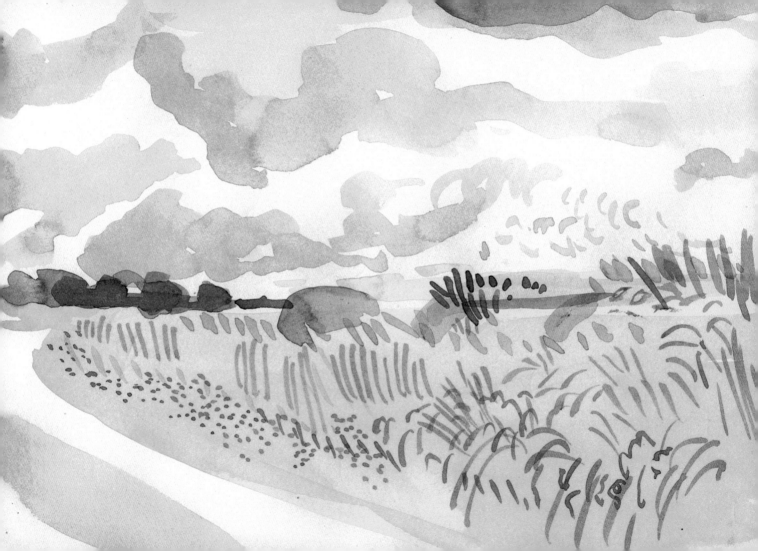

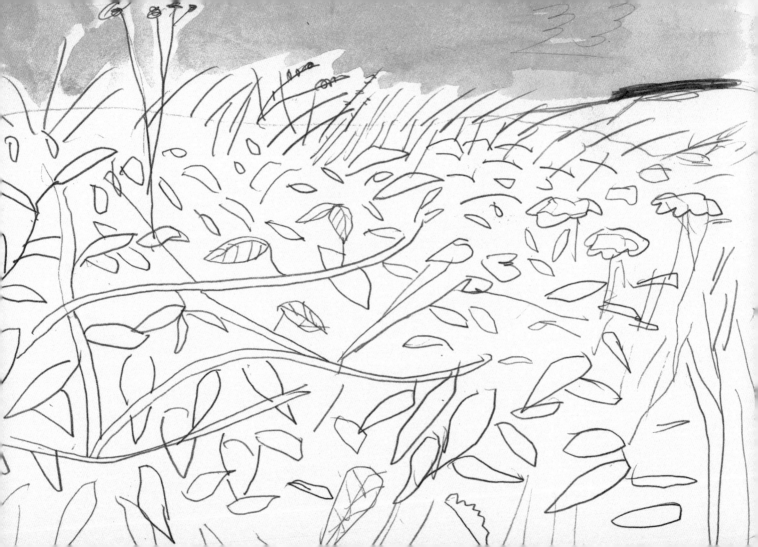

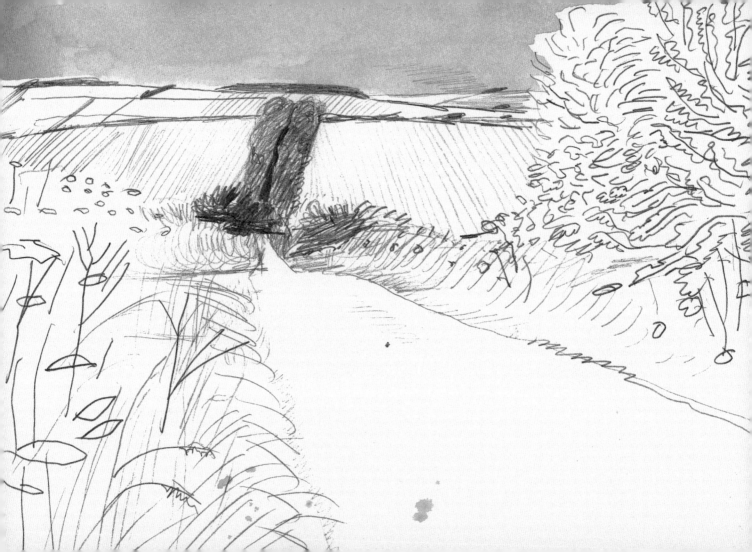

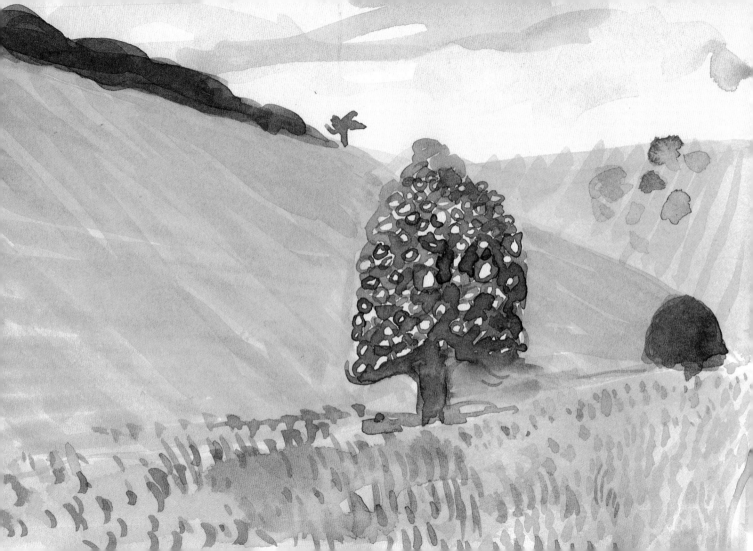

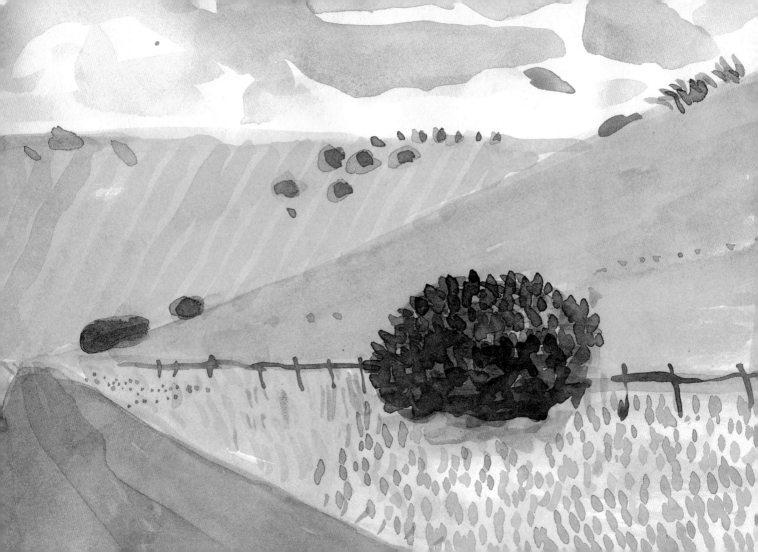

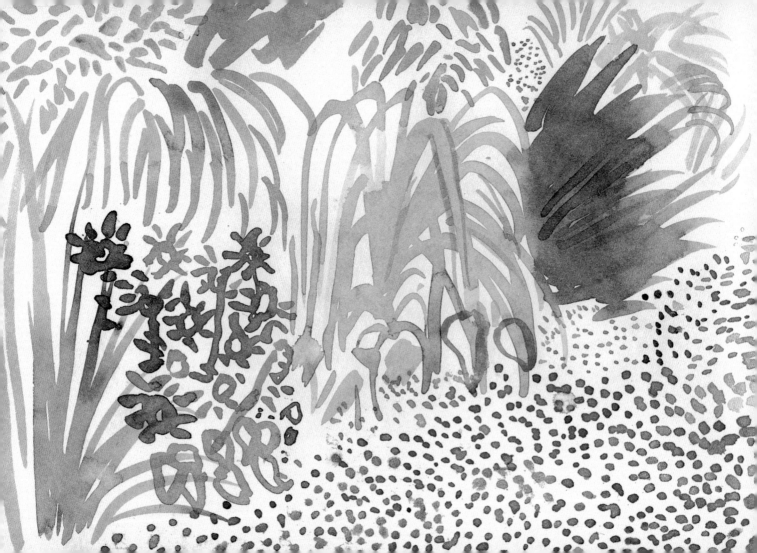

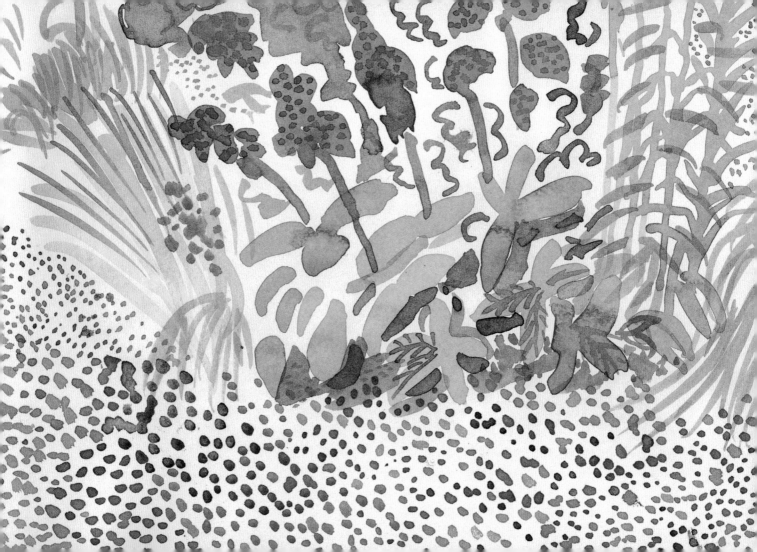

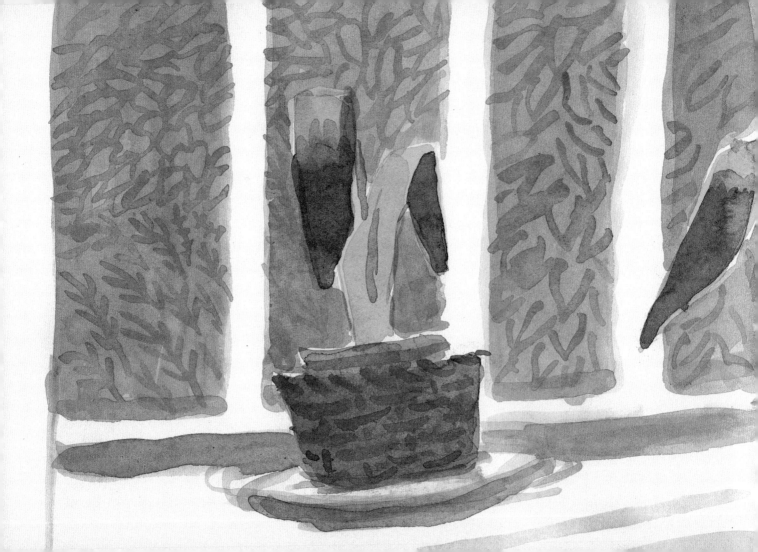

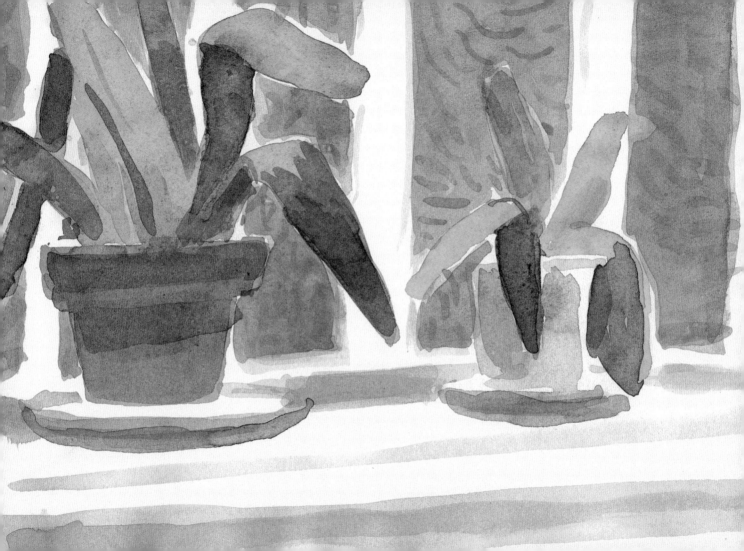

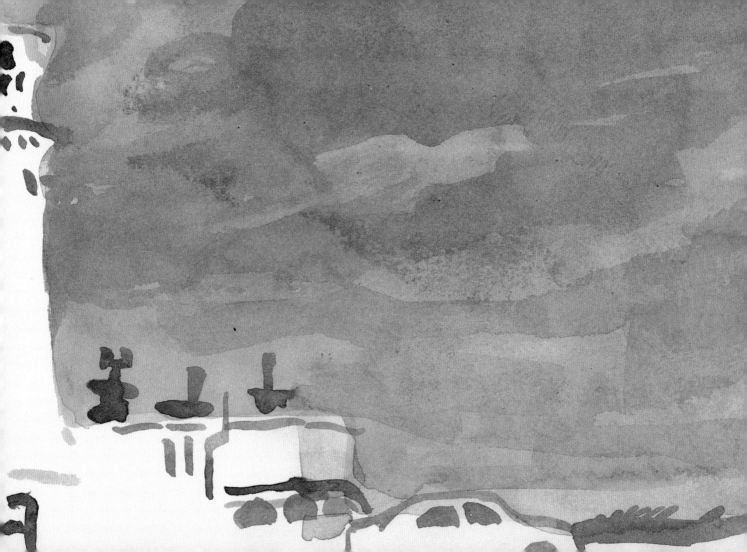

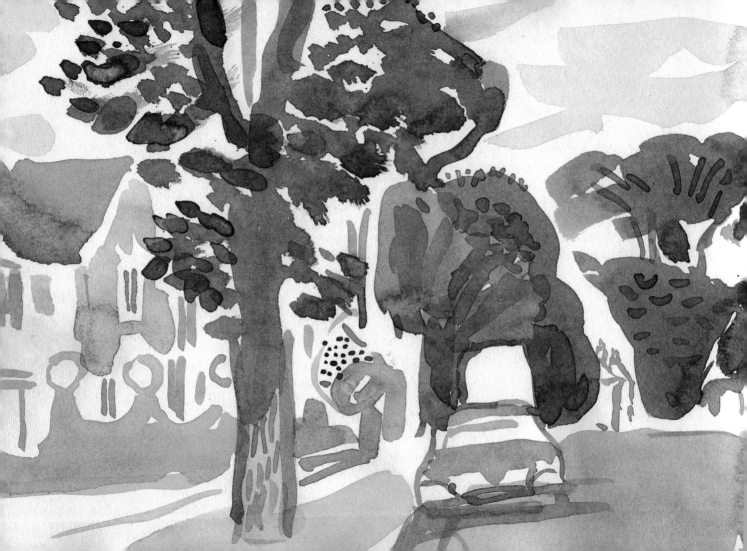

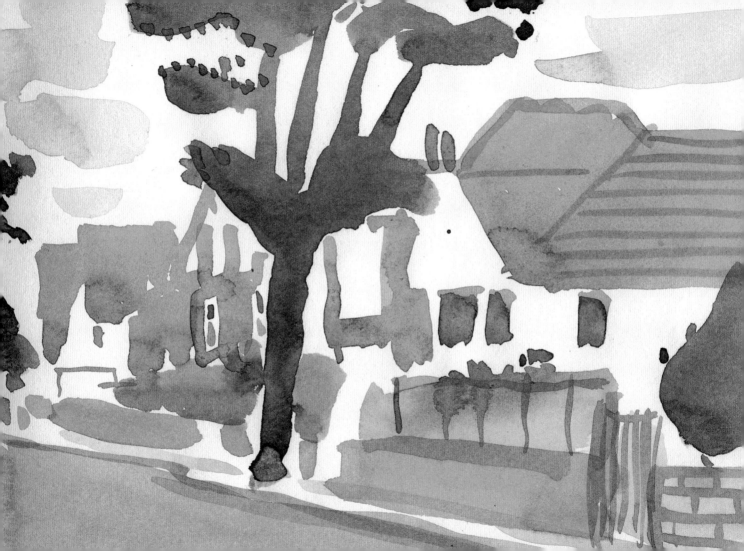

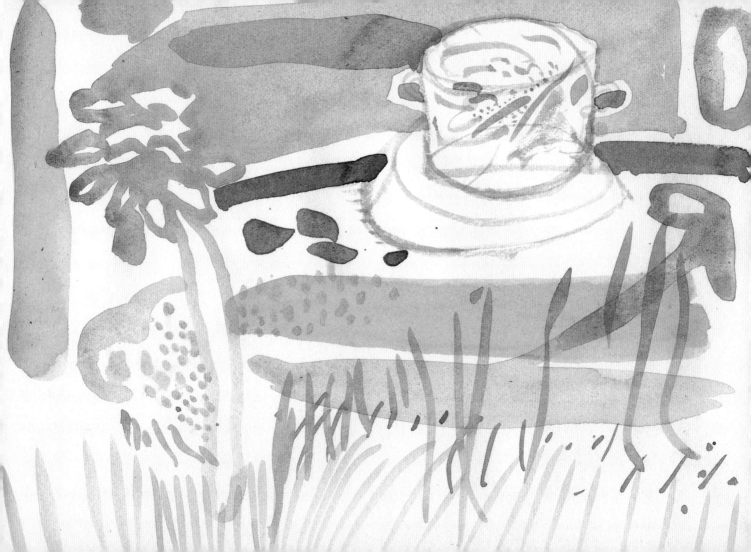

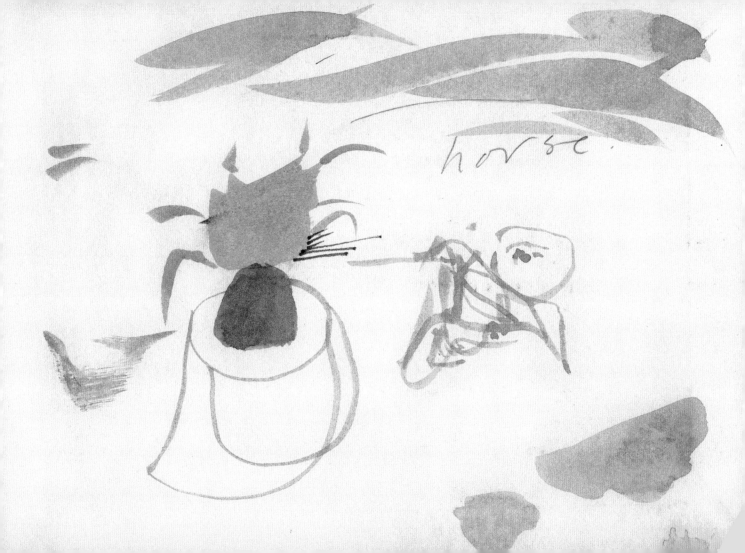

horse.

In this first publication of a 92-page sketchbook used by David Hockney in April 2004, the publishers have omitted pages 19–20, which were left blank by the artist.

Design
Kathrin Jacobsen

Colour origination
DawkinsColour

Printed in Wales by Gomer Press

British Library Cataloguing-in-Publication Data
A catalogue record for this book is available from the British Library
ISBN 978-1-907533-23-5

Distributed outside the United States and Canada by ACC Distribution, Suffolk, Woodbridge, IP12 4SD

Distributed in the United States and Canada by ARTBOOK / D.A.P., 2nd Floor, 155 6th Avenue, New York, NY 10013